THE ICE THAT BURNS

(A Stage Play)

RUBABA MMAHAJIA RAHMA SABTIU

Copyright © 2013 Rubaba Mmahajia Rahma Sabtiu

All rights reserved.

ISBN-13: 978-1492920755

ISBN-10: 1492920754

CONTENT PAGE

- **Acknowledgement**

- **Dedication**

- **Poem:** The Ice That Burns by the Author

- **Disclaimer**

- **The Cast**

- **The Play**

ACKNOWLEDGEMENT

Alhamdu lil Laah, "All praises and adoration belong to Allah".

Glorified indeed be Allah above all else.

May He have mercy on my precious father's soul and on all others.

I thank all of my family & friends, they are precious

DEDICATION

My irreplaceable mum

My family

My friends

To anyone who is like Hajia Nakoowa

My teachers

& You!!!

(Baarakal Laahu fii kum)

THE ICE THAT BURNS

(A poem)

In my eyes is a tear

A mixture of pain and fear

In my mind

A surprise of a kind

The rules are layed

Yet we have swayed

The ice was cold

In my hands I could not hold

Then it became hot

Like boiling water from a pot

The ice now burns

My stomach it turns

Our rule, the Qur'an

The tool for our imaan

A weird path we have chosen

A strange language we have spoken

When will we hold onto the rope?

As I look I see hope

But when will we return?

How will we show concern?

For a way of life ordained

For greatness of purpose to be attained

Somehow! Sometime! Somewhere!

RMRS

DISCLAIMER

All characters in this play are fictitious. Any resemblance to real persons, living or dead, is purely coincidental. I apologise if this play was unable to deliver the message in the most perfect manner to everyone. May God forgive me for any mistakes and accept my efforts. Please pray for all those who worked hard for this to become a reality. This play should not be staged without the prior permission of the author.

By the author

THE CAST

HAJIA NAKOOWA

A philanthropist and the mother of Tawakaltu

MMANMU

Meiriga's mother

FADIKAFUTA

Baabani Ruky's husband and Sarauniya's father

MEIRIGA

A very stubborn boy

SARAUNIYA

A very stubborn girl

TAWAKALTU

A good girl

SHEIKH NAASIR

An Islamic Scholar and leader

BAABANI RUKY

A friend to Mmanmu and Sarauniya's mother

MISS NARRATOR

MR NARRATOR

PLAY BEGINS...

(Stage opens with Mr Narrator sitting on his calves on a prayer mat in a prayer manner and facing the audience. Miss Narrator enters from behind him and stares at him as she moves to the other side of the stage. She stands there and stares at him quietly)

MR NARRATOR:

(He turns his head to the right) Assalaamu alaikum warahmatul Laah. *(He turns to the left)* Assalaamu alaikum warahmatul Laah. *(He picks up a tasbeeh and mumbles some words. He raises his hands up and mumbles again and then he rubs his face with his palms. He then stands up, folds the prayer mat and puts it under his arm)* Alhamdu lil Laah.

MISS NARRATOR:

(Smiling) May Allah accept from you.

MR NARRATOR:

Ameen! Ameen! Ameen!

MISS NARRATOR:

(To the audience) That was one. But there are five!

MR NARRATOR:

Like a tree with numerous branches, there are more under the five.

MISS NARRATOR:

For the second one, you have just seen. The first…. *(She pauses)*

MR NARRATOR:

The first is……. *(Lights go out on stage and come on again with Meiriga seated on a stool in a corner)*

MEIRIGA:

(He tries to light some marijuana) Nonsense! This small thing that I did too they want to lock me up in some prison. Who are the police? Do they know what I am capable of? *(Tawakaltu enters and he hides*

the marijuana)

TAWAKALTU: Ei! This world is really becoming unbecoming. *(To the audience)* Should I not thank Allah for the parents He has blessed me with? Should I not thank Allah for the good manners He has blessed me with? *(She sees Meiriga and she rushes to where he is).* Subhaanal Laah! Meiriga, is this you?

MEIRIGA: *(He laughs loudly)* No. No. No. As your two clear eyes can see, it is not I. It is rather you.

TAWAKALTU: *(Sadly)* Oh Meiriga! Why have you decided to turn yourself into a monster? Why have you decided to make your life this miserable? Why have you sold your soul to the enemy? Why....

MEIRIGA: *(He roars and she moves back a little)* If you don't get out of my sight this minute! If you do not get out of my sight this very minute! You will see how much I was paid by the devil after selling my soul to him. And Oh! You would not like it! You would not like it at all!

TAWAKALTU: *(She puts her hands around her waist and stares at him)* Oh Meiriga! The knife is sharpened! The oven is heated! But look at the goat, *(she points to a corner of the stage. Meiriga turns to look at the corner but does not see anything).*

MEIRIGA: *(He looks up)* Oh God! Help this girl!

TAWAKALTU: *(Sadly, she points to the corner again)* No, Meiriga! Just look at the

goat! *(He turns to look at the corner again but he doesn't see anything)* Just look at the goat, Meiriga! It is still comfortably eating the fodder.

MEIRIGA:

(Confused) If you are crazy, I am even crazier so I warn you again; get out before you regret.

TAWAKALTU:

Are you not like a brother to me? Must I not show sorrow at your lack of reasoning? And what can you do to me that would be so different from what you have already done to other innocent people? Or are you going to make me one of your rape victims?

MEIRIGA:

(Angrily) Stupid girl! Of what use are you to me that I would waste my time on you. Get out! Get out before my wrath befalls you!

TAWAKALTU:

Just look at you. You're not even twenty yet but look at you. You are more than an old man already *(He lights the marijuana)*. Didn't your teachers warn you against drug abuse?

MEIRIGA:

(He stands up angrily) Get out of here before you cry!

TAWAKALTU:

(Scared, she begins to rush out) And you call yourself a Muslim. Shame unto you *(She exits)*.

MEIRIGA:

(He laughs loudly) How dare her! How dare her! She will be taught a lesson. *(The marijuana falls)* Laa ilaaha illal Laahu Muhammadan rasulul Laah *(Lights go out and come on with the two Narrators on stage)*.

MISS NARRATOR:

(She goes down her knees and sits on her calves. She raises her hands up) I bear witness that there is nothing worthy of worship but God and I bear witness that Prophet Muhammad is a messenger of God.

MR NARRATOR:

That is the first.

MISS NARRATOR:

(Standing up) And it would always be the first. But the speech of the tongue is like an echo that is not heard when it disagrees with the intention of the heart! *(They stare at the audience for a while and exit. Lights go off and come on with Mmanmu and Baabani Ruky standing as they chat).*

MMANMU:

(Angrily) And the way we affectionately call her Hajia Nakoowa like hungry dogs sniffing around for some food is probably making her think that all of us feel enslaved to her. I just detest her. Everything about her simply annoys me.

BAABANI RUKY:

(Her hands folded in front of her) All she knows is 'My husband! My husband!' It bores me sick. Is she the only one who has been blessed with a good husband? And are we the only ones who have been cursed with the bad ones? I really fail to understand her sometimes.

MMANMU:

She thinks that she is the only one who has a good husband and upright children. I just hate her. She is such a pain. But for her, all of our stories would have been the same; the women who married the bad men and gave birth to impossible-to-control children. Full stop! *(They laugh)*

BAABANI RUKY:

(She pats Mmanmu's shoulder) Mmanmu, you made an omission. I would rather put it as; the bad women who married the bad men and gave birth to the bad children. *(They laugh again)* After all, didn't the Qur'an say that bad women are for bad men?

MMANMU:

Ei! Baabani Ruky? Are you sure there is anything like that in the Qur'an. Hmmm! I do not want the curse of Allah on my life Ooo! I have had a great share of that already. *(They laugh loudly. They hear voices in the background and keep quiet to listen)*

VOICE ONE:

Keep quiet! Sheikh Naasir is coming. I believe he is going to give a sermon again *(After a short while)*.

SHEIKH NAASIR:

Assalaamu alaikum my brothers.

VOICES:

Wa alaikum salaam Sheikh.

SHEIKH NAASIR:

No! No! No! Get up! You are indeed very respectful. I hope you are all very fine.

VOICES:

Yes, Sheikh! As you can see, we are ok and we are whiling away time.

SHEIKH NAASIR:

Alhamdu lil Laah! *(Silence in the background)*.

BAABANI RUKY:

(Laughing) These boys are in trouble today. He is going to give them

those short sermons of his.

MMANMU:

(Also laughing) Oh! How I wish I can go and redeem them. But let's hear them. We can't afford to miss it *(She pulls Baabani Ruky and they move a little closer to the direction of the voices).*

VOICE TWO:

Exactly Sheikh Naasir.

SHEIKH NAASIR:

And also remember to take advantage of your youth before your old age, your health before your sickness and your wealth before your poverty just as the Prophet Muhammed…

VOICES:

Peace and blessings of Allah be upon him

SHEIKH NAASIR:

Had taught us.

VOICES:

Thank you very much Sheikh.

VOICE TWO:

We will try very hard.

SHEIKH NAASIR:

Well, try very hard. Assalaamu alaikum warahmatul Laah!

VOICES:

Wa alaikum salaam Sheikh. *(Silence in the background again. Mmanmu and Baabani Ruky quickly rush back to where they were at first)*

MMANMU:

Do you think he is coming this way?

BAABANI RUKY:

I don't think so. I guess he was passing by those vagabonds after Asr prayers at the Islamic Library Masjid. You know he is sometimes the Imam there.

MMANMU:

Oh! That means he would not pass this way. *(They see Sheikh Naasir enter and they keep quiet and frown at him without his notice. He stops and walks towards the audience)*

SHEIKH NAASIR:

(Angrily) Here is the dance floor!

Where are the dancers?

Those who instigated the songs

The songs that the musicians sing

From the soil emerge the results of the seeds we put in it

Our youth!

Where are their fathers and their mothers?

Why do they watch our future crush before our eyes? *(Sadly)*

Strength against weakness

Hardwork against laziness

Discipline against waywardness

Now against later *(He pauses and turns to Mmanmu and Baabani Ruky and they turn away from him. He turns to the audience angrily)*

If you threw a ball to the wall

Then you should better look for somewhere to run to

Because! Because! Because!

Back to you it will bounce! *(He calmly walks towards Mmanmu and Baabani Ruky)*

SHEIKH NAASIR:

(Standing a little away from them and smiling shyly) Assalaamu alaikum my mothers! *(They pretend not to hear)* Assalaamu alaikum my mothers!

BAABANI RUKY:

(They turn to look at him) Oh! It is you! Mallam! Eh! How are you?

SHEIKH NAASIR:

(Still smiling) Alhamdu lil Laah, I am doing very well. I hope you and your families are also well by His grace.

BAABANI RUKY:

We are ok. No complains.

SHEIKH NAASIR:

(To Mmanmu) Mmanmu, I greeted you.

MMANMU:

(Coughing) Yes! Sorry, I heard! My throat hurts that is why I didn't respond immediately.

SHEIKH NAASIR:

May Allah protect you from that and may He make things easy for all of us. Assalaamu alaikum!

BOTH:

Ameen *(He exits).*

BAABANI RUKY:

(She puffs) Such nonsense! Could you imagine?

MMANMU:

You do have patience. After insulting us in the Masjid, he comes to us behaving as if he is an Angel and you are patient enough to respond to him.

BAABANI RUKY:

I just wanted him to hurry up and leave us. You know him, he can start a sermon right here. Besides, if he had mentioned our names in his khutbah today, I would have dealt with him very well.

MMANMU:

Of course you would say this. You were not there when he said what he said that is why. It would have been better if he had mentioned our names. The adjectives he used to describe us are pathetic enough *(They become motionless and Miss Narrator enters. She walks around them and then she walks between them to the front of the stage).*

MISS NARRATOR:

When you are greeted with a greeting

Respond with a much better greeting or at least with an equal one

That is in Surah An-Nisa, The Women, Chapter four verse eighty six

And that is one of the many branches.

MR NARRATOR:

(He enters) Yet they say they belong to it

To what?

To Islam and they call themselves… *(He turns to Miss Narrator and they both stare at the women).*

MISS & MR NARRATOR:

 Muslims *(They exit slowly and the women come into motion).*

MMANMU:

 (She taps Baabani Ruky) Have you heard?

BAABANI RUKY:

 No, unless you tell me. *(She points to some chairs)* Look, let's sit down; I have about an hour or two more to spare.

MMANMU:

 (They sit) I have the whole of my life to spare *(They laugh).* Have you heard that Alhaji Baaba Nagoobe is giving people's husbands jobs?

BAABANI RUKY:

 (Frowning) And you haven't told me? You are a bad friend Mmanmu.

MMANMU:

 (Laughing) I'm sure you will laugh when you hear what kind of job that is. Besides, is it not an insult to us in this community?

BAABANI RUKY:

 (Wondering) An insult? How?

MMANMU:

 Must he be the one helping our husbands always? Must he be the one with the good name always? Are our husbands not equally men?

BAABANI RUKY:

 (Surprised) Look, I've always agreed with you on virtually everything but this one. *(She shakes her head in disagreement)* I don't think I agree with you at all.

MMANMU:

 Mmmm! You don't know what you are saying?

BAABANI RUKY:

Yes. See the way our husbands have thrown their responsibilities into our faces. What do they do apart from sit at joints, gossip and gamble their lives away? Mmanmu, think twice about this.

MMANMU:

But we haven't left our husbands because of that, have we? We like them the way they are. Is gossip and gambling not better than a shameful job?

BAABANI RUKY:

What job is more shameful than what your son, Meiriga does?

MMANMU:

(Smiling) And what your daughter does. We are in the same soup together so mind your words my friend.

BAABANI RUKY:

(Laughing) Ok! We are even. But on a more serious note, what is the job about?

MMANMU:

Salesmen at his supermarkets. Our grown up old men husbands as sales men in his supermarkets *(They see Hajia Nakoowa rush in and they stand up)* Ei! Hajia Nakoowa! *(Hajia Nakoowa turns to them and she smiles).*

HAJIA NAKOOWA:

Assalaamu alaikum my sisters. It's been so long since I saw you two.

BAABANI RUKY:

Oh Hajia! We always come to your house with our mouths. Just forgive us.

MMANMU:

We wanted to come and thank you for your favours and kindness towards us and our families.

HAJIA NAKOOWA:

Never do that. Let us all thank Allah. But haven't you heard what has happened?

BOTH:

(Surprised) What?

HAJIA NAKOOWA:

Hmmm! Allah subhaanahu wata aalaa has shown his might again. We lost Alhaji Baaba Nagoobe about an hour ago.

BAABANI RUKY:

(They are both shocked) How do you mean?

HAJIA NAKOOWA:

(Almost in tears) He died during Jum'a prayers.

MMANMU:

(She covers her mouth in shock) Subhaanal Laah!

BAABANI RUKY:

This is unbelievable! What happened?

MMANMU:

Is this a dream? I was at his place just yesterday night.

HAJIA NAKOOWA:

(She wipes her eyes with a handkerchief) Innaa lil Laahi wa innaa ilaihir raaji uun. That is what we should be saying right now as Muslims my sisters. I came to pay someone a visit around the vicinity when I was called about his death and I am on my way to Alhaji's

house. You could come with me if you want *(They followed her slowly and they exit as Mr Narrator enters).*

MR NARRATOR:

Life, very delicate. Death so inevitable. Every soul shall taste death, says Allah. Yesterday night, Alhaji Baaba Nagoobe and Mmanmu had a beautiful chat *(He becomes motionless and voices are heard in the background).*

MMANMU:

I can never thank you enough for your help. My son would have rotten in jail if it hadn't been for you.

ALHAJI BAABA NAGOOBE:

I don't like it when people thank me. Alhamdu lil Laah is enough.

MMANMU:

May Allah bless you and your entire family.

ALHAJI BAABA NAGOOBE:

Ameen. But I have something to tell you. Don't be offended. You are like a sister to me.

MMANMU:

I won't be offended Alhaji.

ALHAJI BAABA NAGOOBE:

I live in peace with my wives because whenever they go wrong, I try to correct them and when I go wrong, they don't hesitate to correct me either.

MMANMU:

I can see that Alhaji.

ALHAJI BAABA NAGOOBE:

Good. Now, go home and think about this. Almost all your family members are mentioned in issues of indiscipline. You are always at loggerheads with this person or the other. You are known for saying things about people that are not true and many such. Your husband is just being a deviant in his duties to his home and society. Your sons and daughters are one trouble or the other. I want you to ask yourself this question: 'Where from all that kind of lifestyle?' I will tell you two things: 'A woman is the one who makes a peaceful home and as a Muslim, you must live your life as if you would die tomorrow' *(Mr Narrator comes into motion).*

MR NARRATOR:

And today, he is dead. Never would the preacher get to lie at his grave side because he lived his life as if he would die today. He looked extra ordinarily bright in his very neat white three-in-one dress. He wore white sleepers and a white cap and he sat right behind the Imam in the Masjid at Jum'a today. Everyone stared at him as he entered, always coming in very early. At the last sujuud, his forehead remained to the ground. After prayers, they tried to lift him up but...... *(He pauses and heaves a sigh).* But he was gone *(He shakes his head).* Indeed, in this; there is a sign of greatness in the sight of Allah *(He exits and Miss Narrator enters).*

MISS NARRATOR:

Isn't it funny and sad? The woman whom they hailed insults at a couple of minutes ago, that was Hajia Nakoowa. Hmmm! But look at how lovely they had treated her? *(She shakes her head)* This is indeed depressing *(Miss Narrator exits and Sarauniya enters wearing a long loose dress that covered her whole body with a head scarf).*

SARAUNIYA

(She frowns and looks at herself) I just hate this dress. Look at how boring it looks *(Baabani Ruky enters).*

BAABANI RUKY: *(She stares at Sarauniya)* Why are you talking to yourself?

SARAUNIYA: Can't you see how ugly I look?

BAABANI RUKY: Ugly? But you are a beautiful girl. Who lied to you that you are ugly?

SARAUNIYA: I didn't say I am ugly. I said I am looking ugly *(She points to her dress)*. See my dress.

BAABANI RUKY: I'm sorry if I offended you but is anyone forcing you to wear this dress?

SARAUNIYA: Of course. Why do you allow Sheikh Naasir to come to this house almost every other day?

BAABANI RUKY: Go and ask your dad because it is to him that he comes.

SARAUNIYA: You won't believe how daddy screamed at me when I dressed up to go out and he made me wear this *(She points to her dress)*.

BAABANI RUKY: Why didn't you come to tell me?

SARAUNIYA: *(Rudely)* What could you have done? Honestly, when I get to where I'm going, I'll take it off *(She begins to walk away)*.

BAABANI RUKY:

Where are you going to and when are you returning? *(She exits without answering)* Why did I even ask? *(Fadikafuta enters holding a walking stick. She turns to see him)* Ehee! I was even waiting for you. Why did you force Sarauniya to wear what she doesn't want to wear?

FADIKAFUTA:

(He pulls a chair and sits on it) Bismil Laah! *(He stares at her for a while)* I'll pretend I didn't hear that.

BAABANI RUKY:

Don't you know that she's a young girl and she needs to look her best in order to get a husband?

FADIKAFUTA:

And who propounded that theory? I've been bad enough. I can't afford to see my children walk in my footsteps when I have seen its end.

BAABANI RUKY:

(Laughing) And how are you going to do that when they have already chosen your path? There is no going back you know.

FADIKAFUTA:

Point of correction, 'Our path'. *(He bows his head and he lifts it up again)* I'll try my best till I die *(Lights go out on stage and come on with Sarauniya standing with her hands on her waist).*

SARAUNIYA:

Why has he taken this long? I hope he is not trying to stand me up? *(Tawakaltu enters holding a huge polythene bag).*

TAWAKALTU:

Assalaamu alaikum Sarauniya.

SARAUNIYA: Wa alaikum salaam.

TAWAKALTU: You are looking great in your dress.

SARAUNIYA: Thank you.

TAWAKALTU: Are you coming for the workshop at Makaranta?

SARAUNIYA: Yes, I would be there.

TAWAKALTU: All right then. I would see you there insha'a Allah. Assalaamu alaik *(Meiriga enters as Tawakaltu exits).*

SARAUNIYA: *(Annoyed)* Why have you left me standing here as if I were some street child?

MEIRIGA: *(Angry)* I'm not in a very good mood girl so mind your language *(She begins to smile).* What was Tawakaltu talking to you about?

SARAUNIYA: Forget about that girl. She doesn't know how much she annoys me.

MEIRIGA: You have not answered my question. Stay away from that girl if you want to have it easy with me.

SARAUNIYA:

She's just a school mate.

MEIRIGA:

(Frowning) And why are you wearing this?

SARAUNIYA:

My dress is under it. I had to cover it up because they said it is indecent.

MEIRIGA:

(He laughs) What do they know about indecency? I have something for you. You will love it.

SARAUNIYA:

(Happily) What is it?

MEIRIGA:

Some golden jewelry I got.

SARAUNIYA:

(Surprised) Wow! Subhaanal Laah! I can't wait to see it *(Lights go out and come on with Miss Narrator and Mr Narrator at the opposite sides).*

MISS NARRATOR:

Subhaanal Laah! That is what she said for a gift from a thief.

MR NARRATOR:

The Lord, Allah, be glorified above all else. How is that possible? Does Allah not hate theft?

MISS NARRATOR:

Does Allah not hate fornication?

MR NARRATOR:

Does Allah not hate drug addiction and sexual assault?

MISS NARRATOR:

Does He not hate disrespect for parents and indecency which they love?

MR NARRATOR:

And that is Islam and they say they are Muslims. What a contrast that is *(They exit slowly and lights go out and come on with Fadikafuta sitting on a chair whilst Sarauniya sits on the floor crying).*

FADIKAFUTA:

(He stands up) Why do you want to kill me this soon? *(He begins to cry)* Haven't I tried enough to correct my mistakes? Look at yourself. You are young and you have a great chance to make your whole life fulfilling. I say had I known today because I did what you are doing yesterday. I can never force you to be better than me but I can try and I will try till I die. *(He begins to walk out and he turns to her)* You see, even in the most urgent of situations, your mother is nowhere to be found. Is that the kind of woman you want to become someday? *(She cries loudly).*

SARAUNIYA:

Oh father! I am so sorry.

FADIKAFUTA:

(He turns to her and begins to sing as she cried) Now I see the truth in me. A never ending greed, blinded by my own deeds. *(He comes to stand in the centre)* So true what they say. We know but we play but today I would say, if you turn me away, to who else can I pray? If you turn me away, to who else can I pray? *(He exits as Tawakaltu runs inside and she pulls Sarauniya to herself).*

TAWAKALTU:

Oh Sarauniya! Are you ok? I'm so glad that you are alive at least.

SARAUNIYA:

Hmmm Tawa! I've ruined my life. I was so close to death.

TAWAKALTU:

But you didn't die. Allah has just given you a second chance so thank Him.

SARAUNIYA:

If I were at the workshop this wouldn't have happened to me.

TAWAKALTU:

Stop crying. Allah knows best. What matters is that you are alive.

SARAUNIYA:

Meiriga put me in trouble. How could he love me like this?

TAWAKALTU:

(She begins to sing) If you ask me about love and want to know, about it? My answer would be; it's everything about Allah! The pure love, to our souls. Creator of you and me, the Heavens and the whole universe. The one that made us whole, and free. The Guardian of His true believers. So when the time is hard, there is nowhere to turn as He promised He'll always be there. Allahu Akbar! Allahu Akbar! Allahu Akbar! *(Lights go out and come on with Baabani Ruky and Mmanmu walking slowly as they chat).*

BAABANI RUKY:

You won't believe how much he has changed until you pay me a visit and he starts a sermon.

MMANMU:

Really? So how are you coping?

BAABANI RUKY:

He is making the children so unhappy? Almost every day, Sheikh Naasir is in our house by invitation. Sarauniya was going out this morning and he made her change her attire because he thinks it is indecent.

MMANMU:

Is it that bad?

BAABANI RUKY:

Now, everything the children and I do is haraam and it requires a lengthy sermon. I really don't want to make enemies out of my children. I even get confused about what to do sometimes.

MMANMU:

Why do you stoop so low for him to trample upon you and your children's rights like that? Hasn't he seen Sheikhs who are even worse off than us? Is he not a breaker of Islamic rules himself?

BAABANI RUKY:

He has stopped all the bad things now. You know, because of his recent accident, I don't want to do anything to increase his pain *(Tawakaltu enters hurriedly)*.

TAWAKALTU:

(Sadly) Assalaamu alaikum my mothers.

MMANMU:

You don't look so well. Is anything wrong?

BAABANI RUKY:

Oh Mmanmu! Don't you know that Tawakaltu is always looking as if something is about to fall from the sky? She's taken Islam really serious.

TAWAKALTU:

Haven't you heard about what has happened to your children?

BOTH:

Our children?

TAWAKALTU:

Yes. Sarauniya and Meiriga.

BAABANI RUKY:

(Sadly) What has happened to my daughter?

MMANMU:

(Calmly) What trouble has Meiriga called for again?

TAWAKALTU:

Sarauniya is ok and in the house. Meiriga is in the hospital *(Baabani Ruky rushes out)*.

MMANMU:

What did he do this time?

TAWAKALTU:

He went on a robbery expedition with his friends yesterday night.

MMANMU:

Of course, that is the usual story. When will this boy ever change? Continue my daughter. What happened?

TAWAKALTU:

He took someone's jewelry in the process and he brought it to Sarauniya. They were at one of the clubs in town when he and his friends had an attack from the police and they tried to fight back.

MMANMU:

So he was shot? *(Tawakaltu nods).*

TAWAKALTU:

He is in the hospital now. *(Mmanmu walks out slowly)* Oh God! Please have mercy on us. *(She begins to sing)* Your signs awake us from our sleep. Your test of pain that hurts so deep. But without your light we cannot realize how far we have strayed. If you turn us away, to who else can we pray? If you turn us away, to who else can we pray? *(She exits. Lights go out and come on with Fadikafuta, Sarauniya and Mmanmu seated quietly).*

SARAUNIYA:

(Crying) Mmanmu, please take it easy.

MMANMU:

Don't worry about me my dear, I'm used to this *(Tawakaltu enters).*

FADIKAFUTA:

(At Tawakaltu) What happened?

TAWAKALTU:

(Sadly) Raafani Muktar was arrested.

FADIKAFUTA:

(Surprise written on their faces) What? How?

TAWAKALTU:

Meiriga became conscious today and they handcuffed him. The police had been guarding him all these while.

FADIKAFUTA:

So why did they arrest Muktar?

TAWAKALTU: They have been looking for his family members so when they got to know he was his father, they arrested him.

MMANMU: So if I had gone with him they would have arrested me too?

SARAUNIYA: They are even looking for me too. What am I going to do?

FADIKAFUTA: *(Angry at Sarauniya)* If you are locked up behind bars for a couple of minutes then you would know why life is better when you take heed to advice.

TAWAKALTU: I told my mother about it so she is gone to the police station.

FADIKAFUTA: *(Shaking his head)* Hmmm! Hajia Nakoowa never tires of the troubles we give her. She is indeed for all of us.

MMANMU: *(Shaking her whole body)* Ei! Ei! Ei! *(She supports her jaw with her left hand and they all become motionless. Alhaji Baaba Nagoobe's voice is heard in the background).*

ALHAJI BAABA NAGOOBE: Good. Now, go home and think about this. Almost all your family members are mentioned in issues of indiscipline. You are always at loggerheads with this person or the other. You are known for saying things about people that are not true and many such. Your husband is just being a deviant in his duties to his home and society. Your sons and daughters are one trouble or the other *(They come into motion and Mmanmu cleans her tears).*

MMANMU:

> My family is ruined. *(They become motionless again and Alhaji Baaba Nagoobe's voice is heard in the background again).*

ALHAJI BAABA NAKOOWA:

> I want you to ask yourself this question: 'Where from all that kind of lifestyle?' I will tell you two things: 'A woman is the one who makes a peaceful home and as a Muslim, you must live your life as if you would die tomorrow' *(They come into motion and Mmanmu starts crying loudly. Sarauniya and Tawakaltu console her).*

MMANMU:

> I have made so many mistakes. Too many of them. I have wasted my life.

FADIKAFUTA:

> *(Sadly)* It will always be bitter to look at the past but we hope and pray that it remains history. Our today must not look like our yesterday though our yesterday will forever haunt us. *(He stands up)* Look at me; I have become an old man by force. Look at what smuggling has done to my life *(He sits down).*

MMANMU:

> *(Shaking her head)* Laa ilaaha illal Laah *(They become motionless and Miss Narrator enters).*

MISS NARRATOR:

> Hypocrisy! Hypocrisy! Hypocrisy! A true manifestation of hypocrisy. What does she mean by Laa ilaaha illal Laah? *(Mr Narrator enters).*

MR NARRATOR:

> What does she mean by there is no god but God, Allah? Why does she say one thing and do the other? What are the implications of saying Laa ilaaha illal Laah? *(They exit and they come into motion. Sheikh Naasir enters).*

FADIKAFUTA:

You are welcome Sheikh Naasir. How did it go?

SHEIKH NAASIR:

(Looking tired) Thank you my brother. In all things, we give thanks to Allah. Hajia Nakoowa says I should tell you that Raafani Muktar has been granted bail and Meiriga has come out of coma but no one should go to the hospital for now.

TAWAKALTU:

(Heaving a sigh of relief) At least this is good.

SARAUNIYA:

What about Meiriga's friends?

SHEIKH NAASIR:

It is sad. Two of them died on the spot, two others will be disabled for life and one lady is still in coma.

SARAUNIYA:

(Crying) O God! What is this?

MMANMU:

So is Meiriga ok?

SHEIKH NAASIR:

He is ok but…

FADIKAFUTA:

But what?

MMANMU:

Tell me Sheikh Naasir. I can take it. You know this is not the first of its kind even though this is worse enough.

SHEIKH NAASIR: The doctors said that they suspect his head hit something in the course of the uproar so he might have some mental problems.

MMANMU: Eh! So finally, my son chose madness? What else Sheikh?

SHEIKH NAASIR: Some of his friends were found to be HIV positive and he... *(He pauses).*

FADIKAFUTA: And he what? *(They all stare at him in horror).*

SHEIKH NAASIR: *(He bows his head)* He has the virus.

TAWAKALTU: Laa ilaaha illal Laah *(Fadikafuta bows his head. Sarauniya stands up with so much fear).*

SARAUNIYA: What have I gotten myself into? *(She faints and lights go out and come on again. Mr and Miss Narrator enter from different sides).*

MR NARRATOR: *(To Miss Narrator)* Have you heard?

MISS NARRATOR: No! You tell me?

MR NARRATOR: The whole community faces the town council next week.

MISS NARRATOR:

The whole community? For what?

MR NARRATOR:

The whole community pays a very huge fine.

MISS NARRATOR:

A fine? For what?

MR NARRATOR:

(To the audience) In doing ablution and gusul, there are signs for those who say they are Muslims.

MISS NARRATOR:

Really, in them are signs most wonderful for a people who understand.

MR NARRATOR:

The whole community is dirty yet they all say Laa ilaaha illal Laah. How can you worship Allah when you are dirty and your environment is dirty?

MISS NARRATOR:

That is impossible. The Muslim and dirt must be in contrast. But why the sudden compatibility? But Mr Narrator, why the whole community? Mma Rahina, the kooko seller is clean and Uncle Duniya, the grave digger is clean also.

MR NARRATOR:

And Hajia Nakoowa, and Mmanmu, and Baabani Ruky and many others. All of them are neat people but how many are they that are clean among they that are dirty?

MISS NARRATOR:

(Nodding) An insignificant number indeed *(Sheikh Naasir enters in a*

very sad mood. Mr and Miss Narrator move to the edges and Sheikh Naasir comes to stand in the middle).

SHEIKH NAASIR:

(To the audience) Why would Muslims be involved in such outrageous issues? Ei! Allah, are we ever going to move forward as a people? *(Fadikafuta enters).*

FADIKAFUTA:

(Surprised to see Sheikh Naasir) Sheikh Naasir, what are you doing here all alone?

SHEIKH NAASIR:

(Walking towards him) Hmmm! Fadikafuta, haven't you heard what has happened?

FADIKAFUTA:

No, I haven't.

SHEIKH NAASIR:

Hajia Nuria and two other Muslim ladies cursed one another using some river goddess and I learnt that two days ago one of the ladies died and yesterday another died and so Hajia Nuria has reported the case to the Chief Imam because she is afraid to be the next to die.

FADIKAFUTA:

This is shocking. Is this some idol worship? What brought about all that?

SHEIKH NAASIR:

They fought because of a man. One of the ladies' husband wanted to marry Hajia Nuria as a second wife and the family did not want her because of the difference in tribe so they used his wife and an aunt of his against her.

FADIKAFUTA:

(Sarcastically) Tribalism?

SHEIKH NAASIR:

They cursed one another with a river goddess in the course of one of their uproars.

FADIKAFUTA:

What else can I say Sheikh? May Allah save us from our own evil.

SHEIKH NAASIR:

Ameen. Aha! You didn't tell me about Sarauniya's HIV status.

FADIKAFUTA:

Hmmm! She was negative but pregnant. The police found out that the boys raped a certain girl in the club just before the attack from the police and they got the virus from her so Sarauniya couldn't have contracted the virus.

SHEIKH NAASIR:

Ok! So is Meiriga responsible for the pregnancy?

FADIKAFUTA:

(Crying) Oh Sheikh! My whole being is full of shame and I wonder if Allah would ever forgive me.

SHEIKH NAASIR:

(Smiling) Allah subhaanahu wata aalaa forgives all sins provided we genuinely repent unto him and we don't return to our sins.

FADIKAFUTA:

Sarauniya does not even know the father of her child. She gave names and they all denied and she is still giving names. I never knew my daughter was a call girl Sheikh. I think only a DNA test can tell which of the names is actually responsible.

SHEIKH NAASIR:

(Shaking his head) Innaa lil Laahi wa innaa ilaihir raaji uun *(Lights go out and come on with Sarauniya sitting on the floor with some pills and a glass of water in her hands).*

SARAUNIYA:

(Crying) I have messed up my life. At seventeen years and unmarried, I am not a virgin. I lost that years ago. I am pregnant with a bastard and I cannot even tell out of the many who the father could possibly be without a DNA test. What a shame! My father cries every day because of me. My mother wants me to have an abortion. Wouldn't that add to my sin or even kill me? *(She becomes motionless and Miss Narrator enters).*

MISS NARRATOR:

(Staring at her surprisingly) An abortion? No my dear! Don't do it! That is murder. Allah hates it. If you kill an individual, you kill a whole nation says Allah *(She exits and Sarauniya comes into motion again).*

SARAUNIYA:

Wouldn't it be better if I ended it all with just some few pills so that I could have peace forever *(She becomes motionless again and Mr Narrator enters).*

MR NARRATOR:

(Laughing loudly and staring at her) Peace forever? Suicide plunges you into a deeper hell. Better the pain you feel now than the pain you would feel after *(He exits and she comes into motion again. Baabani Ruky is about to enter but she goes back to hide in a corner watching Sarauniya).*

BAABANI RUKY:

(Happily) Good, she's about to do the abortion. Yaa Allah! Please give her the courage to do it *(Sarauniya looks around and seeing no*

one she raises the glass to her lips and she was about to put the pills in her mouth when Hajia Nakoowa and Tawakaltu enter. She quickly put both away).

HAJIA NAKOOWA: *(Sensing something was wrong, she kneels beside Sarauniya and Tawakaltu does the same)* Why are you crying my dear? Didn't I tell you to stop giving yourself negative thoughts? *(Baabani Ruky frowns and remains there. Tawakaltu sees the pills).*

TAWAKALTU: *(Picking the pills)* Mummy, look at these.

HAJIA NAKOOWA: *(At Sarauniya)* What are those Sarauniya?

SARAUNIYA: My mother wants me to do abortion but I'm so scared so I wanted to kill myself.

BOTH: Subhaanal Laah! *(Baabani Ruky suddenly covers her mouth with her hands in shock).*

HAJIA NAKOOWA: This is dangerous. Very dangerous. How can Baabani Ruky possibly tell you to do that?

BAABANI RUKY: *(She walks in slowly and sadly)* You wanted to do what? *(She begins to cry).*

HAJIA NAKOOWA: I think you have to come and stay with me instead.

SARAUNIYA:

(She begins to sing as she cries) Yaa Maulaa! Yaa Yaa Kareem! Yaa Ghaafiraz zanbi! Yaa Aalim!

HAJIA NAKOOWA:

No! No! No! Stop it. Stand up and let's go inside (Lights go out and come on with Mmanmu sitting on a stool and looking stressed up).

MMANMU:

What you put in the mill is what comes out of the mill indeed. I am reaping the evil I sowed and I dare not raise my hands to Allah to pray for a better situation. The Angels would push my hands away and that would be fair enough (Hajia Nakoowa and Tawakaltu enter).

HAJIA NAKOOWA:

Assalaamu alaikum.

MMANMU:

(Turning to see who it was) Wa alaikum salaam Hajia. (They enter and Mmanmu gives them a seat) Oh Hajia, you and your daughter never get fed up with us.

HAJIA NAKOOWA:

Allah never gets fed up with us upon all the bad things that we do so we don't have to get fed up with one another.

MMANMU:

Hmmm! You do have faith Hajia Nakoowa and I wish I could have a little of that.

HAJIA NAKOOWA:

You look very exhausted. What is going on with you?

MMANMU:

Hmmm! Nothing is going on with me other than what I worked hard

HAJIA NAKOOWA: for?

Don't speak like that Mmanmu. You make me sad.

MMANMU: Don't be sad. Every day you work so hard for laughter and we worked so hard for the hardship we are going through today and no one should be made to bear the burden of the other so let us enjoy the fruits of our labour. That is truth.

TAWAKALTU: *(She stands up)* Mummy, I'm going to see Meiriga.

HAJIA NAKOOWA: Ok. I'll be with you soon.

MMANMU: Go my dear, I just cleaned him up. Like mother like daughter indeed.

HAJIA NAKOOWA: I was going to ask, who has been taking care of him?

MMANMU: Who else other than me? All his siblings have dejected him and his father who loved him so much is going about chasing women instead of giving me some dignity by at least choosing a second wife.

HAJIA NAKOOWA: I'll get a nurse to take care of him insha'a Allah, if you don't mind. You are growing old and you shouldn't be doing the kind of work you've been doing.

MMANMU: *(Surprised)* How can I ever thank you enough? *(Sheikh Naasir and*

Fadikafuta enter quickly. They pause when they see the women).

SHEIKH NAASIR:

Sorry. Assalaamu alaikum.

HAJIA NAKOOWA:

Wa alaikum salaam. What is wrong?

FADIKAFUTA:

We don't have much time, could you send Mmanmu inside please?

MMANMU:

And why should she do that?

FADIKAFUTA:

You would get to know later but please do as we say *(They hear a car horn outside).*

MMANMU:

(About to rush out but Hajia Nakoowa holds her back) You have to tell me what is wrong else I'm not moving an inch.

SHEIKH NAASIR:

(At Fadikafuta) I think we have to tell her *(They hear the horn again).*

FADIKAFUTA:

Innaa lil Laahi wa innaa ilaihir raaji uun. We lost Raafani Muktar through an accident today and we want to bring his body inside *(Lights go out and come on with Miss Narrator standing quietly on stage).*

MISS NARRATOR:

So many have gone! So many are going! And so many would go! Now, it is all about Raafani Muktar's death. Everyone is talking about it. Coming out of a hotel with a young lady, they collide with a huge

truck and that was his end. But unfortunately or fortunately, the young lady lives on and she tells the story as it was to all. He had been her regular customer. And I remember the style in which Alhaji Baaba Nagoobe had exited the world! Subhaanal Laah! Verily, in these are signs for men and women of understanding *(Mr Narrator enters sadly)*.

MR NARRATOR:

Glorified be Allah above all else indeed. What is happening to us? What is happening to us?

MISS NARRATOR:

What makes you so gloomy Mr Narrator?

MR NARRATOR:

Oh Miss Narrator! Sorrow fills my heart. Misunderstanding engulfs my mind for how can a Muslim fight his fellow Muslim when Islam teaches peace among Muslims and non-Muslims and for all of humanity?

MISS NARRATOR:

Who are these Muslims who are fighting and hating one another at the anger of Allah and for what reason do they choose the disdain of our Creator and Owner?

MR NARRATOR:

For little differences which are only natural, they have divided. For little differences which are only natural, they fight one another. For trivial reasons, they hate one another.

MISS NARRATOR:

Didn't the Prophet, peace be upon him, tell us that the Muslim is the brother of the Muslim? Didn't he say that none truly believes except him who loves for his brother what he loves for himself?

MR NARRATOR:

Some of us Muslims must really do some thinking and always remember the words of Allah that says; hold fast unto the rope of Allah and be not divided *(Lights go out on stage and come on with Mmanmu, Fadikafuta, Hajia Nakoowa and Tawakaltu seated).*

HAJIA NAKOOWA:

You will be shocked if you see Meiriga. He is almost fully recovered and Tawakaltu's Islamic teacher has been teaching him little by little.

MMANMU:

Really? I thank you Hajia. You are not Hajia Nakoowa for nothing. You do deserve your name.

HAJIA NAKOOWA:

(Smiling) Let us all thank Allah instead.

FADIKAFUTA:

The day Sarauniya came to the house, I couldn't recognise her. She has changed tremendously in everything. Thank you Hajia and of course alhamdu lil Laah for giving us you.

HAJIA NAKOOWA:

Oh Fadikafuta! Alhamdu lil Laah for everything.

FADIKAFUTA:

My heart is gradually becoming content.

MMANMU:

But Fadikafuta, have you gotten any medicine man to take care of your wife's stroke?

FADIKAFUTA:

Hmmm! Hajia here brought a doctor to see her last week and he says he could treat her.

MMANMU:

Hmmm! Hajia! But who is taking care of her now?

FADIKAFUTA:

Sarauniya, some of the other children and I. They are gradually changing for the better and the lifestyle of the eldest is giving me signals that he wants to become an Islamic Scholar *(They all laugh)*.

HAJIA NAKOOWA:

We really need to thank Allah with all our strength and might.

TAWAKALTU:

(To Hajia Nakoowa) Mummy, I want to take something from the car.

HAJIA NAKOOWA:

Ok. Here you are *(She gives some keys to her)*. Just be careful.

TAWAKALTU:

Ok *(She exits)*.

MMANMU:

(Smiling) So what name are you planning to give Sarauniya's child?

FADIKAFUTA:

(He is quiet for a while) We are naming her Samira, after Hajia.

MMANMU:

(Smiling) Perfect! May she grow to become like the one whose name she is going to bear.

ALL:

Ameen.

HAJIA NAKOOWA:

(Smiling shyly) I'm grateful that you see me in that regard. May Allah

look down upon us with His mercy always.

ALL:

Ameen.

FADIKAFUTA:

Hajia suggested that we call her Saakiya as her household name.

MMANMU:

(Smiling) Mmmm! Saakiya. That is very interesting and nice.

HAJIA NAKOOWA:

(She sings) Rahmaanu Raheemal Laah!

MMANMU:

(Sings) Yaa Kareemal Laah!

HAJIA NAKOOWA:

(Sings) Rahmaanu Raheemal Laah!

FADIKAFUTA:

(Sings) Yaa Azeemal Laah!

HAJIA NAKOOWA:

(Sings) Finding you, is relieve. Now we hope, now we believe. Hear us Lord. Strengthen us. Guide us through, our journey. The more we learn to read your signs, the more content is our heart, the more withdrawn towards your light. Open our eyes so we can see the light of hope you sent to us, the rain that brings us back to life. Rahmaanu raheemal Laah!

MMANMU:

(Sings) Yaa Kareemal Laah! *(Sheikh Naasir enters in a sad mood with a newspaper in his hand).*

SHEIKH NAASIR:

Assalaamu alaikum.

ALL:

Wa alaikum salaam warahmatul Laah!

FADIKAFUTA:

You look worried!

SHEIKH NAASIR:

(He sits down) Today's story is sad. How can Muslims be involved in this?

HAJIA NAKOOWA:

What is it this time around? *(Mr Narrator enters and they become motionless).*

MR NARRATOR:

How can Muslims be involved in this? How can Muslims be involved in that? That is always the story *(Mr Narrator goes to stand in a corner. Meiriga enters wearing a white Jalbab and they become motionless).*

MEIRIGA:

Islam was at the north and I was at the south! Are you a Muslim? Yes, I nodded. A life of lies I have led. Creating problems for they who had chosen Islam and lived as Muslims. *(He begins to sing as he cries)* O Lord! Here I am, pleading at your door. Send me your mercy, send me your peace or I am lost for sure. O Lord! Here I am, yearning for your cure. This humble servant will be diverted from you no more.

ALL:

(They come into motion and begin to sing) Oh Allah! Here we are, pleading at your door. Send us your mercy, send us your peace or we are lost for sure.

MEIRIGA:

(Singing) Lately I have, been wondering so. Wondering about, what do I know? About this life and where do I go after I die? How can it be so? Some people say that they don't care, when into my grave I descend but how can my aim of heaven be, when I return to my Lord!

ALL:

(Singing) Oh Allah! Here we are, yearning for your cure. These humble servants will be diverted from you no more. No more O! No more!

FADIKAFUTA:

(He comes to stand beside Meiriga and he puts his hand around his shoulder) It is painful when you go back to history such as the one you have made. It is even much more painful when you go back to the one that I made. One thing consoles us. Allah is All-Forgiving and Most Merciful *(They become motionless and Sarauniya enters).*

SARAUNIYA:

If I could, I would turn back the hands of time to when I was so innocent. No matter the change, there will always be Saakiya, telling me of the story of my life before. She will always be the reminder for me to turn back to Allah in repentance and insha'a Allah, out of her will rise a great Muslim woman who follows Islam *(They become motionless and they hear Baabani Ruky's voice in the background).*

BAABANI RUKY:

(Crying) When I had the power to walk, I walked long distances in search of evil for myself and my family. Today, I am stuck at one place as if I have never moved in my life whiles I yearn to walk at least a mile for the sake of Allah. What sorrow I have called for myself *(Miss Narrator enters).*

MISS NARRATOR:

The right time is now. The next second is no one's concern *(She goes to an opposite corner from the Narrator and Mmanmu stands up).*

MMANMU:

All my youthful exuberance wasted on destroying society and family. In my old age, I struggle to impress Allah. Who am I deceiving? Every pain I go through today is out of my own doing. I pray to receive my punishment here on earth rather than in the Hereafter.

SHEIKH NAASIR:

Allah indeed loves those who sincerely repent unto Him.

HAJIA NAKOOWA:

I am glad for I am seeing and hearing what I have always wanted to see and hear. Life is indeed undulating, taking us up and down and it is always good to have Allah who will stabilize us *(They all become motionless and Tawakaltu enters with a book and a pen. She goes to each one of them and then she opens a new page and she writes something. When she finishes, she closes the book and she comes to the front of the stage).*

TAWAKALTU:

(To the audience) My little mind tells me, these lives are worth recording. My ear is not so big but of course the ear that heeds to the words of advice is not as big as a basket. As I see and hear, I learn. I have come to understand that it is all about choices. I have seen the path that they have chosen and then I have seen where they have ended. I choose a path that will let me end well. I choose to be a Muslim who plays by the rules of Islam *(She becomes motionless).*

MISS NARRATOR:

(She begins to sing) A dream for a day, when there will be, justice and unity. When there is no more anger. No need for fighting. Is it that we

just don't care? We are here for a day or two. Allah help us.

MISS & MR NARRATOR:

(They sing in unison) Salaamu alaik! Salaamu alaik! Salaamu alaikum! *(They come into motion).*

HAJIA NAKOOWA:

Since we are all here, let us go and see the one who could not be here *(Mmanmu and Meiriga exit as they chat happily and Fadikafuta and Sarauniya follow them. Sheikh Naasir and Tawakaltu also follow in a likewise manner and Hajia remains behind. To the audience)* Islam, a most beautiful rule of life. Muslims, a most beautiful family. The two should never be separated because one depends on the other. Allah is great! *(She exits and Miss Narrator comes to the front of the stage).*

MISS NARRATOR:

A good life she has led. May she continue to have a positive impact on people and may she never tire of those who will always want to go astray.

MR NARRATOR:

(Coming out of the corner) Ameen thumma ameen Miss Narrator.

MR & MISS NARRATOR:

(They sing) She came to them. In the hour of need. When there were so lost. So lonely. She came to them. Took their worries away. Showed them the right way. A way to live. She filled their hearts with love. Showed them the light of Allah. And now all they want, is to be with her.

MISS NARRATOR:

(Smiling) I guess the story is done for now.

MR NARRATOR:

(Happily) By Allah's unflinching grace, it is done.

MISS NARRATOR:

Alhamdu lil Laah for His many mercies. *(She turns to the audience)* Hmmm! You have heard it all, right? And of course you have seen it all as well. Think very well and reflect on each issue you have heard and seen. It helps. Assalaamu alaikum warahmatul Laahi wabarkaatuhu *(She turns to Mr Narrator)*.

MR NARRATOR:

Wa alaikum salaam warahmatul Laahi wabarkaatuhu *(She exits and he turns to the audience)*. Are you a Muslim? Yes! Are you compatible with Islam? No! But why? But how? How can an ice burn? How can an ice burn? Muslims and Islam! Muslims and Islam! Islam and us Muslims, conflict or peace? *(He pauses and then he curtseyed)* Thank you and assalaamu alaikum warahmatul Laahi ta aalaa wabarkaatuhu *(He exits)*.

THE END!!!

ARABIC WORDS	MEANING
1. Salaamu Alaikum	Peace be upon you
2. Warahmatul Laah Wabarkaatuhu	And Allah's mercy and His blessings
3. Walaikum salaam	And peace be upon you
4. Innaa lil Laahi	To Allah we belong
5. Wa innaa ilaihir	And to to Him
6. Raaji uun	Is our return
7. Laa ilaaha	There is no god
8. Illal Laah	Except God (Allah)
9. Muhammadu rasuulul Laah	Muhammad is the messenger of Allah
10. Subhaanal Laah	Glorified is Allah above all else
11. Alhamdu lil Laah	All praises belong to Allah
12. Allahu Akbar	Allah is great
13. Asr	After noon prayers
14. Ameen thumma ameen	Amen and amen again
15. Yaa Allah	Oh Allah
16. Haraam	Forbidden
17. Gusul	Ritual bath
18. Maulaa	The Protector
19. Kareem	The Kind
20. Ghaafiraz zanbi	Forgiver of sin
21. Aalim	Most Knowledgeable
22. Yaa	Oh!
23. Azeemal Laah	The Mighty God
24. Kareemal Laah	The Kind God
25. Raheemal Laah	The Merciful God

Rubaba Mmahajia Rahma Sabtiu

www.ingramcontent.com/pod-product-compliance
Lightning Source LLC
Chambersburg PA
CBHW081617170526
45166CB00009B/3012